Fulwood
and the
Mayfield Valley

Presented by
Roger Redfern

The Cottage Press,
Old Brampton, Chesterfield, Derbyshire

Contents

Acknowledgements

My thanks go to the following who have supplied facts or verified details in the text:
Sue Briggs, C. J. Cumming, Martin Decent, Rosanne L. Dronfield, George Edward Flint, Suzanne M. Hellewell, Dave Renshaw, Elaine Sharp, Jane Walker.

Copyright: Roger Redfern 2005
ISBN: 9780954760519
British Library Cataloguing in Publication Data.
Printed by: Kingsbury Press, Doncaster 2009

Fulwood and the Mayfield Valley

No other British city approaches Sheffield in the beauty stakes of its western suburbs. It's a concoction created from crumpled topography, elevations that allow great vistas, and the good taste of past generations and their architects.

It was natural that the first western suburbs developed close to the city, at Nether Edge, Broomhall and Broomhill, but as the nineteenth century progressed the affluent sought homes further out – at Ranmoor, Carsick, Fulwood and Dore.

Modern Fulwood bears little resemblance to the utterly rural agricultural district that existed into the early twentieth century. Though much of what we now see is an attractive suburb it cannot compare with the scattered settlement of beautiful stone farms and cottages that occupied such quaint sites in and overlooking the Mayfield Valley. Many of these holdings still exist though some have been enveloped in that ever-spreading urban sprawl that characterised the twentieth century.

The Mayfield Valley is the centrepiece of the Fulwood district, serene and wooded in its lower half, a wilder clough towards its western headwaters. The main stream is the Porter Brook that rises at about 1,100 feet (350 meters) on the ill-drained eastern slope of Brown Edge, at the edge of the Hallam Moors and just inside the Peak District National Park. Its main tributary has, though, the longer course; it has two small sources at 1,200 feet (365 meters) right upon the National Park boundary at Fulwood Head and flows down by Mill Lane to join Porter Brook just upstream of Carr Bridge.

At the Domesday Survey the manor of Hallam, containing what we now call the Fulwood district, was part of the massive estate of the Norman favourite Roger de Busli. The broad moorlands west of Fulwood Head would have provided ideal territory for the chase - hunting with dogs and with falcons and hawks. In the years before his execution in 1076 the Saxon Earl Waltheof of Hallam would have enjoyed the chase over what has been called one of the greatest such sporting estates in England. Here, too, the Norman Thomas de Furnival granted common pasture to the canons of Beauchief Abbey.

The very name Fulwood (often spelt "Fullwood" in olden times) is derived from Anglo-Saxon words meaning damp or swampy woodland.

This moorland fringe was the obvious area to site the city's first major public water undertaking. The trio of Redmires Reservoirs were built up here at the edge of the Hallam Moors close to the 1,100 feet (350 meters) contour after Acts of Parliament of 1830 and 1845, allowing much needed water to flow by gravity to the burgeoning industrial town to the east.

The housing estates that spread around the old heart of Fulwood between the wars were attractive places to live, with hilly country views and the fresh air of the prevailing winds blowing off the adjacent south Pennine moors. The prospects of modern Fulwood from, say, Ringinglow Road or Cottage Lane may not be very appealing but such development has, at least, allowed many people to enjoy residence in a most satisfactory outskirt of the city.

No-one did more to foster interest in the past of this fascinating district than the late Muriel Hall. Despite her long standing physical affliction she encouraged an enthusiasm for recording the past, was Chairman of The Fulwood Society, and her two books written more than thirty years ago ("The Mayfield Valley" and "More about Mayfield Valley and Old Fulwood") are real gems that keep alive memories of life here that would otherwise have slipped into oblivion.

For more information about the area contact:

The Friends of the Porter Valley, 42, School Green Lane, Fulwood, Sheffield. S10 4GQ.

Stumperlowe Cottage

This is probably the oldest remaining dwelling in the district, formerly derelict, now carefully and sympathetically restored. When the late Bessie Bunker came across Stumperlowe Cottage while gathering material for her book on cruck buildings it was in a sorry state (right).

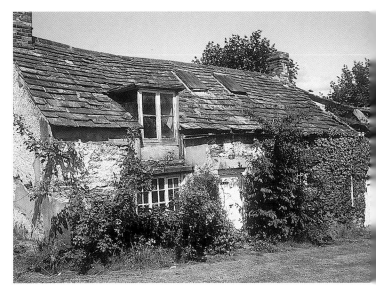

It lies behind the present Stumperlowe Hall (see pages 6 and 7) and consisted of a cottage with attached barn containing four sets of oaken cruck timbers. It probably dates from 1400 and after the present Stumperlowe Hall was erected about 1650 became a labourer's cottage.

The ancient trackway between Hallam Head and High Storrs, Ecclesall passed in front of Stumperlowe Cottage but later building has removed all trace of this, and the extensive lands of this historic farm. The last occupants departed in 1968 and

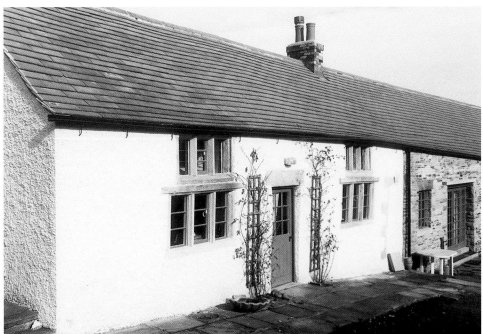

demolition seemed inevitable but far-sighted neighbours Mr and Mrs D. Millar were able to purchase and fully restore it between 1986 and 1993 (left) and moved in at Christmas, 1993.

The entire former barn in now an open living space with three of the remaining cruck timbers soaring to the roof to create the sense of an old-time vaulted hall.

Stumperlowe Cottage is Listed Grade II.

5

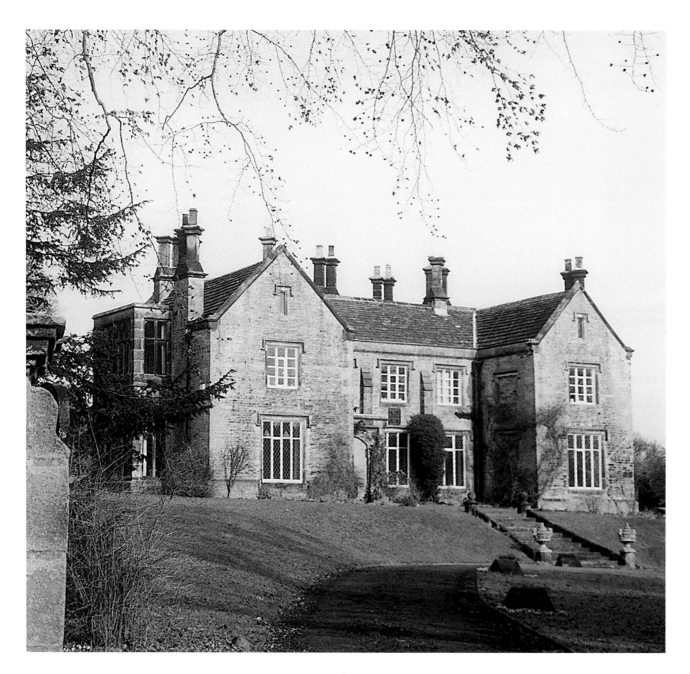

Stumperlowe Hall

The Mitchells were landowners here at Fulwood as early as 1397 but the present house, arguably the grandest in the district, was put up here at the junction of Slayleigh Lane with Stumperlowe Hall Road between 1650 and 1655.

Built by Robert Hall, a descendant of the Mitchells, he and his family lived here for fifty years. By 1716, though, the Halls were forced to surrender Stumperlowe by order of the Sheffield Manor Court. The lead merchant John Hawksworth lived here for most of the remainder of the eighteenth century but the biggest changes followed the mansion's purchase by Henry Isaac Dixon, formerly of Ecclesfield and Page Hall, Pitsmoor, in 1854.

Happily Dixon was a man of taste and his rebuilding involved a restrained and sympathetic style though the enlarged fenestration doesn't compare with the beauty of the original mullioned windows. Dixon also involved himself in local affairs, a leading light and benefactor of Fulwood parish church and conservationist who planted many of the copses of deciduous trees that still enhance this district.

Henry Isaac's son, James, was already living at nearby Fulwood House (see page 10) when his father died in 1912. Stumperlowe Hall was then occupied for a short time by Thomas Kingsford Wilson (1861-1937) of the snuff manufacturing family but a year later James Dixon and T.K. Wilson exchanged houses. Dixon lived at Stumperlowe Hall until 1924 (died 1947) and the house was then divided into two dwellings. In the early thirties it reverted to a single house and in 1957 became the home of Sir George and Lady Kenning, owners of what came to be known as "Europe's largest motoring organisation". After her husband's death Lady Kenning remained at Stumperlowe until her death in 1974.

This grand house looking out over its spacious garden remains today a family home in fine condition.

Stumperlowe Hall is Listed Grade II.

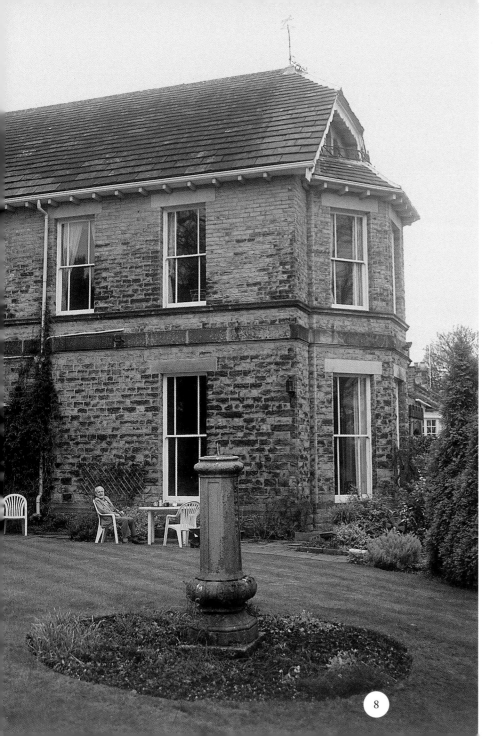

Stumperlowe Grange

Just across Stumperlowe Hall Road from Stumperlowe Hall (see pages 6 and 7) stands Stumperlowe Grange, a large stone house with its back to the thoroughfare and looking for all the world truly Victorian. That, though, is only half the story.

It was originally a seventeenth century farmhouse with about fifty acres of land. The typical Jacobean frontage still exists on the garden side. In the nineteenth century it became the home of Samuel Laycock, owner of the famous engineering empire based at Archer Road, Millhouses (its site now partly occupied by Sainsbury's Superstore). Laycock developed political ambitions and in 1862 had a large wing added to his home (seen left) in order that he had a residence commensurate with his office of Mayor of Sheffield.

His son Charles Albert Laycock was born at Stumperlowe Grange in 1855 and later became Managing Director of Samuel Laycock & Sons Ltd. On a round-the-world tour in 1886 his ship "Oregon" sank but all passengers were rescued from small boats though they lost all their belongings.

Much of the land at Stumperlowe Grange was sold off for house building in the first half of the twentieth century. About 1926 the house itself was divided and remains so today. Miss Betty Laycock finally sold the Victorian half that had been in her family for well over a century in 1960. It remains a private house in fine condition looking out over its mature, secluded, walled garden.

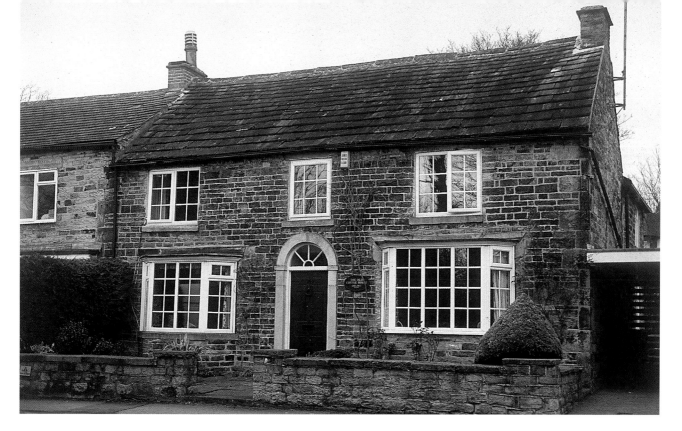

The Old Coffee House

The original road from Sheffield climbed the hill from Nethergreen to keep left along today's Old Fulwood Road, skirting the now vanished Stumperlowe School Green. By 1880 a strong influential temperance movement was developing nationally and the vicar of Fulwood opened a coffee house at the bottom of Brookhouse Hill in the hope of tempting local inhabitants from strong drink.

When the Blacksmith's Arms public house adjacent to what was Stumperlowe School Green, alongside Old Fulwood Road, became empty in 1888 the vicar saw his chance and asked Henry Isaac Dixon of Stumperlowe Hall (see page 7) if the building might be converted to a more satisfactory Coffee House than the one beside Brookhouse Hill. Permission was granted and subsequently more than £350 was collected for the conversion. In July, 1888 a grand opening was performed with many Sheffield worthies present, including the Mayor and Master and Mistress Cutler.

More than coffee was on offer here; there was a summer house and field for picnic parties, and a clubroom where "parochial meetings will be held in the winter". The first manager, appropriately, was the parish scripture reader.

The establishment continued in business until 1936 having done its bit to keep local folk off the demon drink for almost half a century. Thereafter the Old Coffee House became an attractive private house.

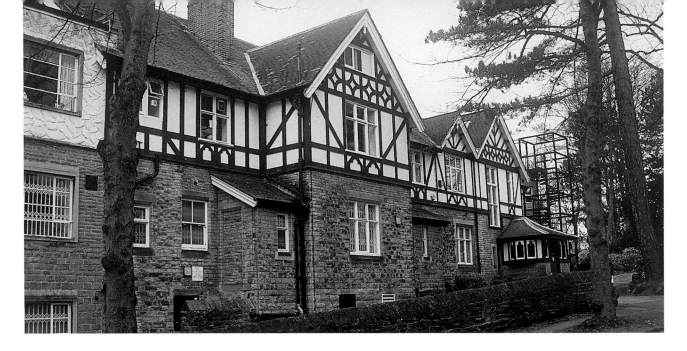

Fulwood House

Work began on the construction of Fulwood House, almost opposite the Old Coffee House beside Old Fulwood Road, in 1911 but the onset of the Great War meant that manpower was at a premium and it wasn't completed until 1920.

Though built for the well known Wilson family, Sheffield snuff manufactures, it seems that the James Dixon (son of Henry Isaac Dixon of Stumperlowe Hall - see page 7) was living here in the partly built house in 1912. At the same time Thomas Kingsford Wilson was living at Stumperlowe Hall while his new home was completed. A year or so later it was decided the logical thing to do was exchange houses.

T.K. Wilson became chairman of Tennant's Brewery and is best remembered as perhaps the finest shot in the Sheffield area. By 1935 he was able to claim a total bag of grouse for the past fifty years of 150,000 birds, mostly shot on the family's moors at Moscar and Stanage. Wilson paid attention to wind direction in his sport and had a complicated apparatus on the roof of Fulwood House that transferred information to a room below for his convenience.

After his death circa 1935 his window stayed here, eventually leaving circa 1939. The house stood empty for some time before being purchased circa 1948 by the Sheffield Regional Hospital Board and subsequently it became the Trent Regional Offices of the Department of Health. Since the mid sixties this once fine house has been dominated (as is part of the Mayfield Valley) by the offensive tower block erected immediately to the east, proclaiming all that is aesthetically undesirable about the corporate architecture of the 1960's.

The former gardener/coachman's house (Wilson's servant was John Martin) was built at the same time and in the same Edwardian style as Fulwood House across Old Fulwood Road and behind the present Ranmoor Motor Company's garage. It is a most attractive dwelling, and more practical as a 21st century house than Fulwood House could ever be!

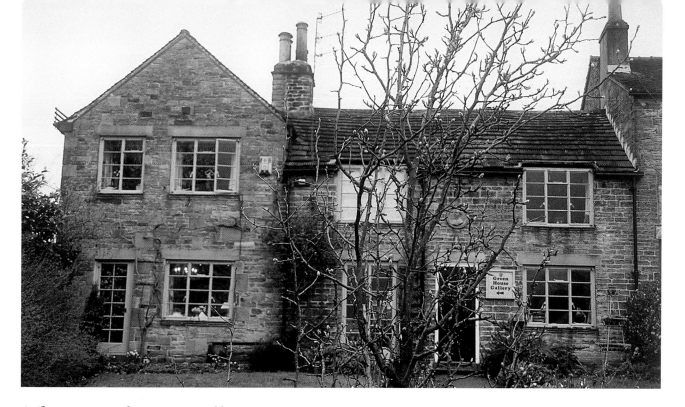

The Greenhouse Gallery

This delightful ensemble of old stone dwellings lies to the left of Slayleigh Lane as it climbs from Fulwood towards Hallam Head. Despite now being surrounded by mature suburbia it retains a certain flavour of rural arcadia.

The central portion was the original Slayleigh Farm, built in the seventeenth century. It was subsequently converted to cottages and the house across the lane became the present Slayleigh Farm (see page 12). In 1840 a pair of labourers' cottages with a higher roofline was added to the right. The numerous well remembered Broomhead family lived here for a long period.

In 1947 the western portion was added (above left), and in 2000 a short wing was added behind. The old, central portion and its post-war addition is the home of the notable landscape artist Martin Decent whose work is published worldwide and who has had commissions from organisations ranging from the National Health Service and Royal Bank of Scotland to the Church of England (see front cover).

The Greenhouse Gallery is based here, providing a different opportunity to view and purchase contemporary paintings by artists from across the country. The gallery has specific planned shows through the year. (For details telephone 0114 230 2609).

A fascinating detail here is the manganese steel plaque on the front wall of the house. It contains a relief portrait of Disraeli and was cast by the steel manufacturer Hadfield in the Don Valley. It was rescued from oblivion and placed here as an adornment by Martin Decent.

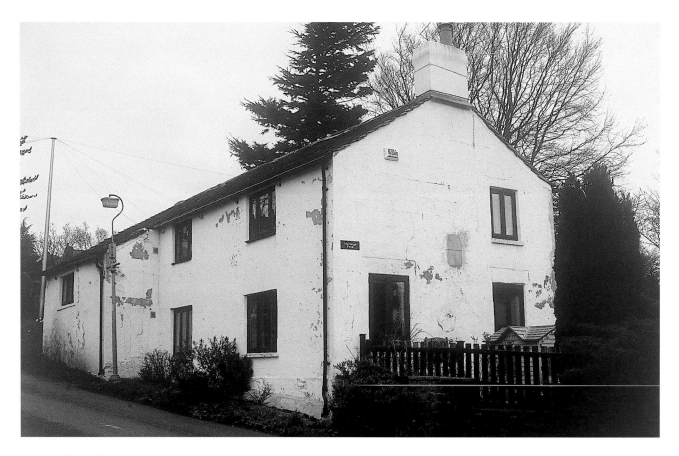

Slayleigh Farm

The stuccoed and white painted walls of Slayleigh Farm stand close to the northern side of Slayleigh Lane, causing an attractive slight bottleneck on this old way as it climbs the hill towards Hallam Head. The former open fields that extended from Fulwood parish church right across this hillside all the way to Lodge Moor and the line of the Roman road is now completely covered by suburbia. Here and there, though, architectural gems lie hidden among the bricks and mortar. One such rarity is Slayleigh Cottages, lurking enigmatically behind high hedges near Chorley Drive.

The stone from which Slayleigh Cottages was constructed in about 1642 was quarried from the Stone Field that lay in front of the building. It is likely these cottages were once occupied by labourers employed at Slayleigh Farm.

Eventually, after World War Two, the cottages were united to form one delightful dwelling by the Thorntons, the well known sweet manufacturers. Here is a linear house, full of character, set secretly behind hedges that separate it from its surround of suburban villas.

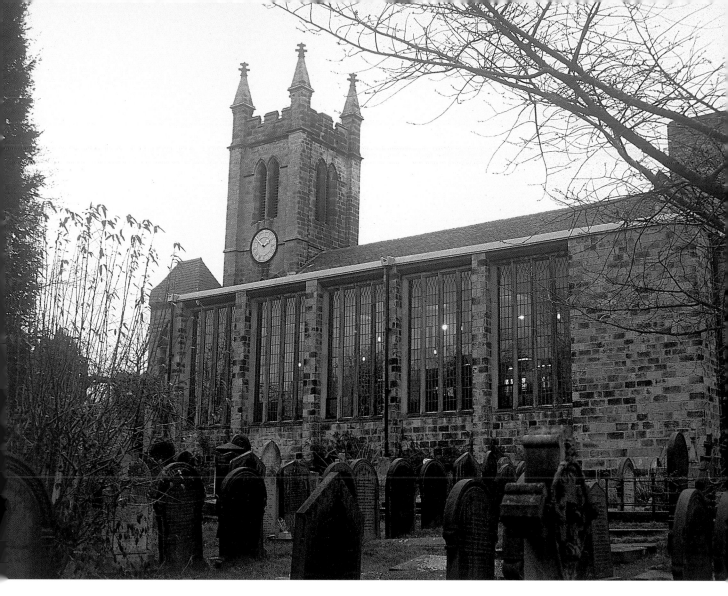

Fulwood Parish Church

Though Fulwood parish was the largest in the Sheffield area the only place of worship in the district up to 1837 was the Old Chapel in Whiteley Lane (see page 16).

continued overleaf

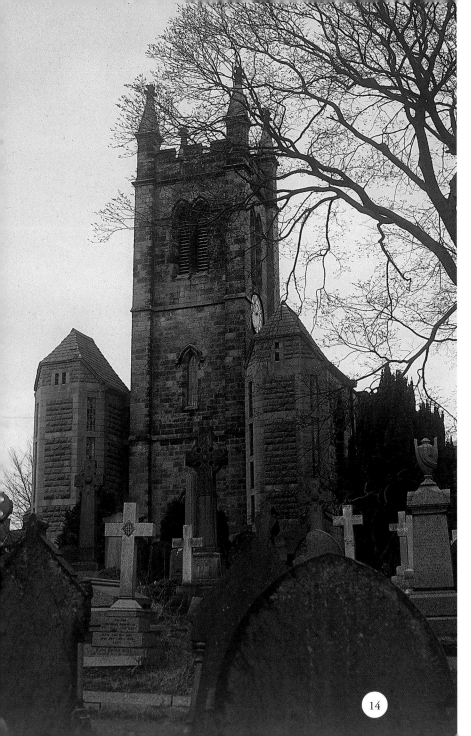

Fulwood Parish Church
continued from page 13

Miss Phoebe Silcock, a spinster living comfortably at Whiteley Wood Hall (see pages 20 and 21), decided to provide the parish with a church appropriate to its size. She made sure the fine new church would be visible from her home across the valley by giving land on the high ridge near Goole Green. She also gave £2,200 for the construction of the church and the Foundation Stone was laid by the Revd. W. V. Bagshaw in 1837.

Robert Potter was the architect of what Pevsner described as "a humble structure in the lancet style with a west tower with obelisk pinnacles". Miss Silcock soon came to the rescue again, providing funds for the new boys' and girls' schools behind the church in 1840. She also provided the site for the first Vicarage in Stumperlowe Lane.

What we see today, of course, is a much enlarged and more attractive building resulting from the enlargements of G. G. Pace. Pevsner calls the alterations "noteworthy". The new parts of the interior are whitewashed and there is a "picturesque" porch at the west end of the new south aisle.

The Bishop of Sheffield laid the Foundation Stone of the Church Centre in June, 1975 which is an extension and enlargement of the former village school mentioned above (which originally replaced the first village school in School Green Lane, see page 17). This imposing Church Centre was opened in 1976 and the final addition was the Youth and Learning Centre, opened in 1991.

Fulwood's Only Street

What is today's Chorley Road used to be an insignificant lane without dwellings alongside it. The end running behind the present parish churchyard (now a cul-de-sac for vehicles) came to be known as Church Lane but for eight years between 1897 and 1905 it was called Chorley Street, the only designated "street" in Fulwood. From 1905 it became Chorley Road.

The brick cottages seen here from the churchyard were built about 1888. The late Muriel Hall (see pages 40 and 41) explained that their erection really marked "the beginning of the invasion of the great Hallam Fields" by suburbia and was the very beginning of the use of red brick for building in the area.

Some of the men living here were scythe and file grinders. The occupiers of the top cottage about 1900 had a cow called "Jubilee" (born in the year of Queen Victoria's Diamond Jubilee in 1897?) which they kept in the back yard. Muriel Hall recounts how the poor beast was housed with its front end in the coal house and its back end in the adjacent privy! A neighbour kept a donkey in the kitchen and pigeons in the attic.

Mrs Pinder lived at the bottom cottage, wore clogs and sold a variety of sweets from her front room, especially to Sunday School scholars on the Sabbath.

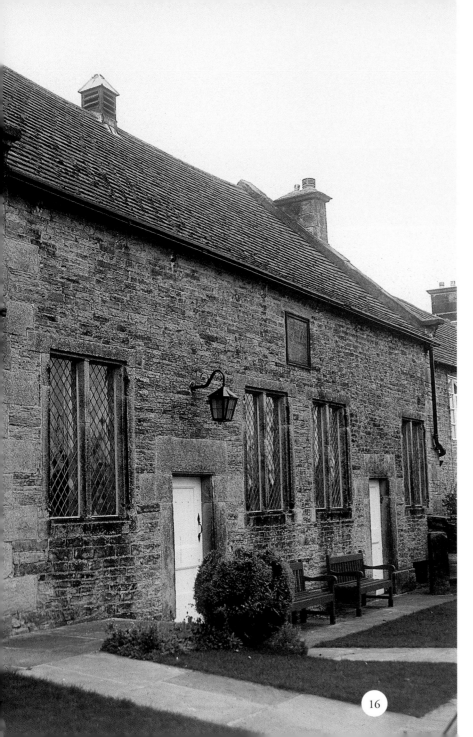

Fulwood Old Chapel

That convinced dissenter William Ronksley of Gunthwaite, near Penistone made provision in his will for the construction of a chapel for the people of Fulwood. He endowed it with £400 and it was built in 1728, overlooking Whiteley Lane. Opposite is the sward of what is now public parkland but was previously a quarry where much of the district's building stone was excavated.

Due to financial problems with Ronksley's original endowment the Old Chapel was closed between 1873 and 1896. Since that time it has been regularly open for Unitarian services, a delightfully plain, stone oblong of six bays with leaded light windows overlooking what is now a widened Whiteley Lane, complete with attached former Parsonage house.

The Old School

Climbing School Green Lane from the top of Whiteley Lane we find Fulwood's first school on the right hand. Built in 1730 a stone plaque above the original doorway lists the benefactors whose munificence brought basic education to this rural district.

As pupil numbers increased space became limited and a new single storey school building was put up just below the original, which then became the schoolmaster's house. It became a private house after Miss Phoebe Silcock's generosity paid for a new school behind the parish church in 1840 (see pages 13 and 14).

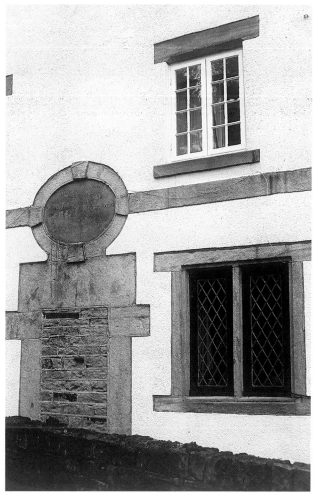

The Stocks

Fulwood's ancient stocks used to stand upon the Green that occupied a great space at the top of Brookhouse Hill and what is now the bottom of Crimicar Lane. The stone uprights were later used as gateposts to a house near the Old Chapel in Whiteley Lane. Eventually they were rescued and the stocks restored. They now stand safely in the front garden of the chapel for all to see.

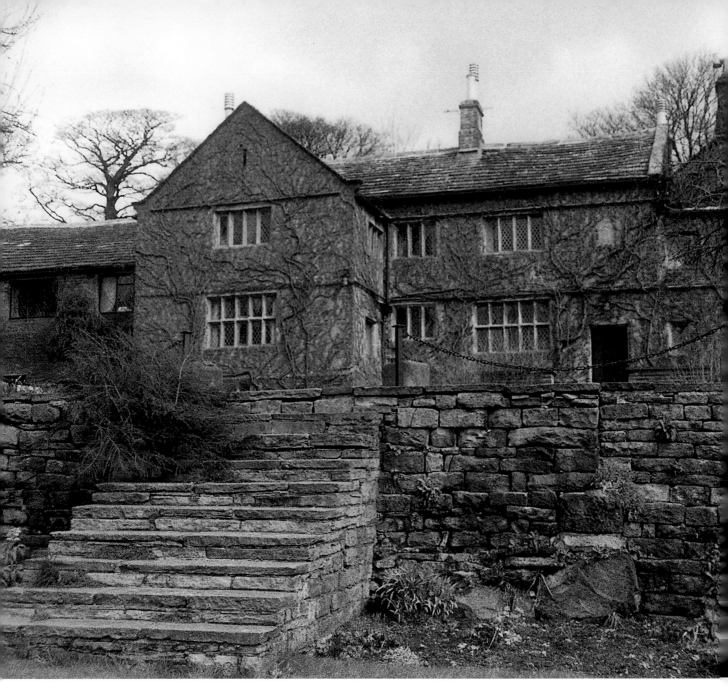

Fulwood Hall

This impressive old dwelling stands on the brow of the hill three quarters of a mile west of Fulwood parish church, close to the 900 feet (275 metres) contour and looking out to the south over the breezy spaces of the Mayfield Valley.

Fulwood Hall existed in the late fifteenth century but was much altered in 1620. At that time it was the home of the Fox family, well remembered yeoman farmers who owned a corn mill in the Mayfield Valley and whose reputation was somewhat tarnished by the spendthrift George Fox who had to sell up in 1707. It was subsequently home to many families and tradition boasted the existence of a tunnel connecting Fulwood Hall with Bennett Grange (about 400 yards distant across two fields to the north-west of the Hall). If such a tunnel did exist both ends have long since been blocked up.

Architecturally typical of many large former yeoman farmers' houses in this district it is as pretty and well balanced a building as any to be found near Sheffield. It looks out over a lovely sloping garden towards the tilting edge of the Peak District moors beyond Fulwood Head, in fine condition and a credit to its current owners.

Fulwood Hall is Listed Grade II.

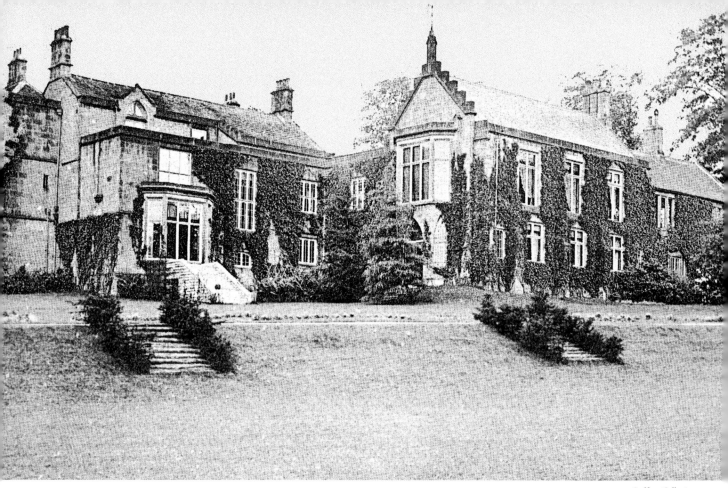

Whiteley Wood Hall

Before Victorian times the only impressive houses in the district were Fulwood Hall, Stumperlowe Hall and Whiteley Wood Hall. The latter stood half a mile to the south of the present Fulwood parish church, across the wooded recesses of the Mayfield Valley.

This photograph (above) shows the house in its final form, having been enlarged and modified several times since its original construction about 1662-3 on land owned by Thomas Dale, on the site of an earlier hall-house.

I can do no better than quote from my description of Whiteley Wood Hall in "Sheffield's Remarkable Houses" (1996): "One of Dale's daughters married Alexander Ashton of Stoney Middleton in 1659 and they built the Hall. In 1741 the Ashton's grandson conveyed the estate to Strelley Pegge but he already had his own house at Beauchief so sold Whiteley Wood to Thomas Boulsover, father of Sheffield Plate, in 1757. The servants were housed in nearby cottages (now called Whiteley Wood Manor and Ivy Cottage, see page 23) and

Boulsover remained here until his death on 9th September, 1788 aged 84.

William Hutton became the next owner then it passed by marriage to the Silcock family. Miss Phoebe Silcock was resident here in the 1830s when her generosity paid for the building of the new parish church (see pages 13 and 14).

From 1864 to 1876 it was the home of Samuel Plimsoll (famous as M.P. for Derby and "the sailor's friend" who was instrumental in passing the Merchant Shipping Act and the creation of the "Plimsoll Line" on ships).

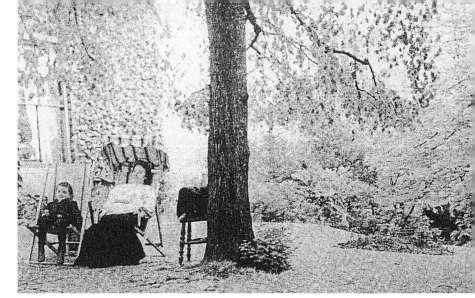

Redfern Collection

The dreadfully hot summer of 1868 prevented the South Yorkshire Miners' Association holding their annual procession in Norfolk Park so Plimsoll invited them to process from Sheffield to Whiteley Wood Hall with twenty silk banners. By 2.00 p.m. 10,000 miners sat on the lawns in front of the house to hear rallying speeches. "My grounds", Plimsoll later recounted, "never look so beautiful as when occupied by Sunday School children or by such gatherings as I now saw before me".

In 1893 the Hall became the home of my great uncle, Arnold Muir Wilson (1857 - 1909) and his family. He was a well known Sheffield solicitor, JP, Town Councillor, traveller and mountaineer. In 1896 the Hall was purchased by Sheffield Corporation but the Wilsons continued to live there. After my great uncle's death in 1909 my great aunt restored (and presumably moved to) adjacent Whiteley Wood Manor (see page 23).

In 1930 the Hall was purchased for use by Sheffield Guide Association but due to lack of funds it steadily fell into disrepair. In 1957 the Council for the Conservation of Sheffield's Antiquities made an abortive bid to preserve the wonderful south front, considered "an unusually sophisticated feature for a house of this type in the north of England . . . and well in advance of other houses of the period in this area - for example, the Peacock Inn, Rowsley and Eyam Hall".

The Hall was, in fact, a complex of different building periods and styles and photographs taken at the turn of the century show much of its exterior covered with Virginia Creeper. The photograph here shows my great aunt Eva Holland and her son Frank Sydney Holland about 1905 and I believe it was taken in the garden at Whiteley Wood Hall when they were visiting Eva's sister, Arnold Muir Wilson's wife. It evokes a summer afternoon in a world that totally disappeared with the outbreak of the Great War. Captain Frank Sydney Holland was killed in France on 27th November, 1917 aged 22.

Attempts to save the Hall failed and it was pulled down in 1957 though the stable block survives" (see page 22).

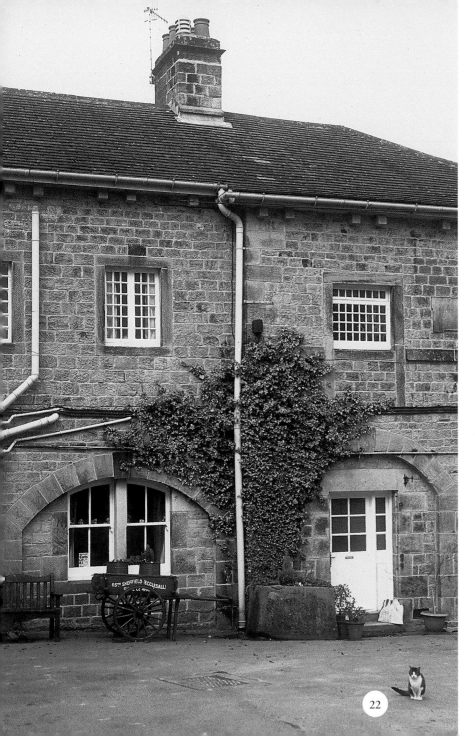

The Stable Block, Whiteley Wood Hall

Though Whiteley Wood Hall was shamefully demolished in 1957 after years of dereliction the impressive stable block remains. It dates from the late eighteenth/early nineteenth century and is in fine condition, thanks to its owner, the County of Sheffield Guide Association. There are cottages within the building and the rest serves as an outdoor activity centre with individual units named after notables associated with the vanished mansion - Boulsover, Plimsoll, etc.

The former arched carriage doorways have long since been reduced in size but one unit still retains the cobbled floor and oak roof timbers of the original stables. Standing in the great courtyard today and looking up to the classical clock on the west wing we still get a flavour of the old days on this large estate.

The high brick wall surrounding the former kitchen garden behind the stable block is in excellent repair and is Listed Grade II.

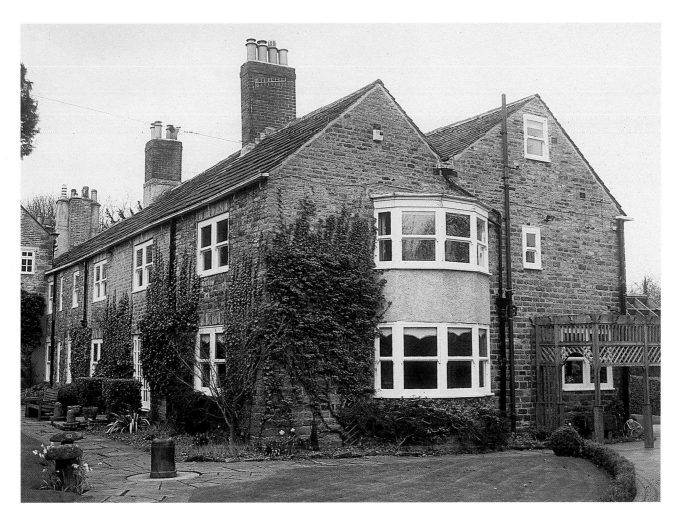

Whiteley Wood Manor

This immaculate house standing to the north-east of the site of the vanished Whiteley Wood Hall overlooks the top of Ivy Cottage Lane with views across Whiteley Woods to Fulwood. It was formerly known as Whiteley Wood Cottage.

It was probably a working farm associated with the Hall and may well pre-date it. It really formed a small hamlet with the adjacent cottages (one called Ivy Cottage) and accommodated Hall servants. After the death of my great uncle in 1909 (see pages 20 and 21) my great aunt restored Whiteley Wood Manor and (presumably) moved there.

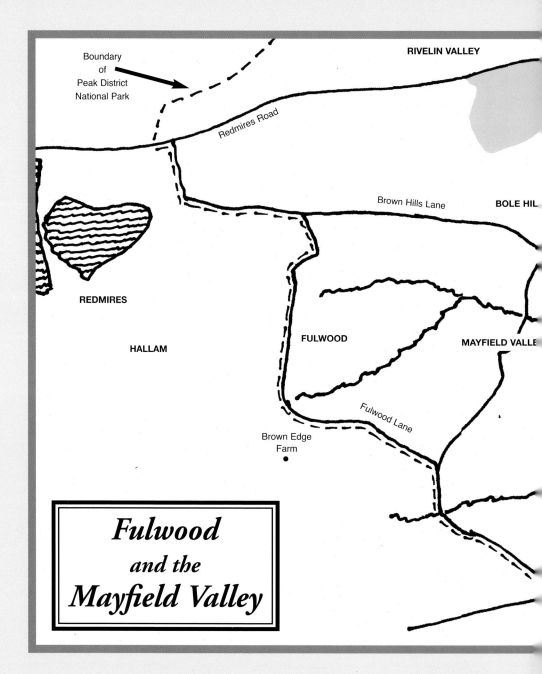

Boundary
of
Peak District
National Park

RIVELIN VALLEY

Redmires Road

Brown Hills Lane

BOLE HIL

REDMIRES

FULWOOD

MAYFIELD VALLE

HALLAM

Fulwood Lane

Brown Edge
Farm

Fulwood
and the
Mayfield Valley

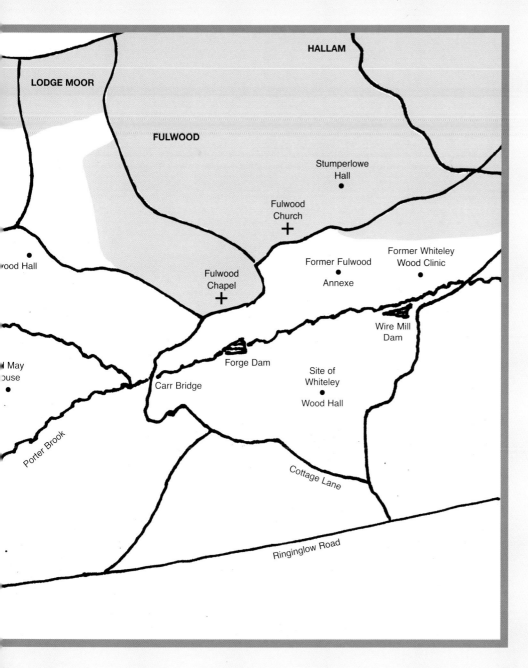

HALLAM

LODGE MOOR

FULWOOD

Stumperlowe
Hall

Fulwood
Church

Former Whiteley
Wood Clinic

ood Hall

Former Fulwood

Annexe

Fulwood
Chapel

Wire Mill
Dam

May
ouse

Forge Dam

Carr Bridge

Site of
Whiteley

Wood Hall

Porter Brook

Cottage Lane

Ringinglow Road

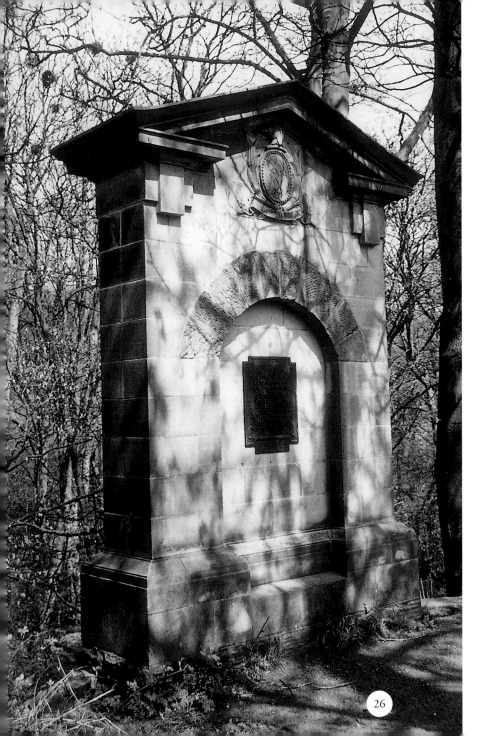

The Boulsover Memorial

Down in the wooded confines of the valley below the site of Whiteley Wood Hall lies the Wiremill Dam, beside which Thomas Boulsover built his rolling mills in 1762. He was the inventor of Sheffield Plate twenty years earlier, a process of successfully plating snuff boxes, cutlery and other items with silver which stimulated a great expansion in the town's trade.

In Hunter's Hallamshire (1869) Boulsover is described as "the ingenious mechanician". Certainly he was one of a handful of pioneers who put Sheffield on the world industrial map. In the spring of 1929 David Flather erected this beautifully proportioned memorial to Boulsover within a few yards of the site of the great man's rolling mills.

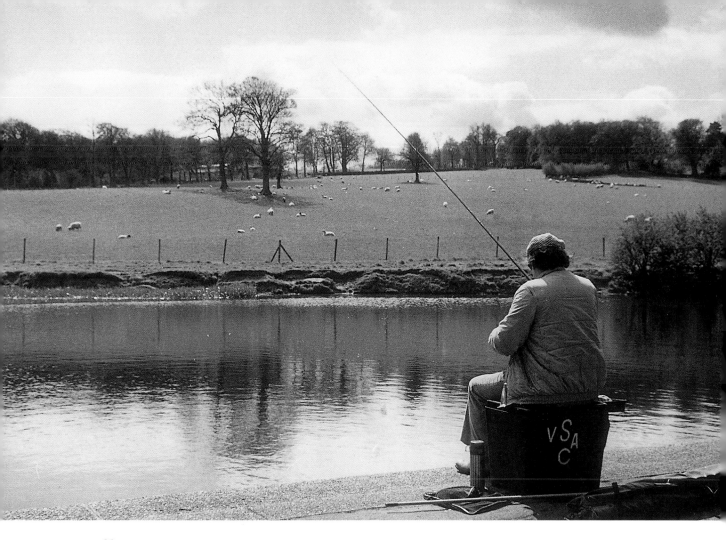

Wiremill Dam

Walking upstream from Endcliffe Park, never far from the sight and sound of the tumbling River Porter, the pedestrian soon reaches the penultimate of the string of dams that provided "green" energy for the various early industrial undertakings that marked the true beginning of Sheffield's manufacturing might.

This is Wiremill Dam, beside which Thomas Boulsover built his rolling mills in 1762 (see opposite). Though industry has long gone this dam still delights the eye and offers recreation for those with time to enjoy it. Atop the hill seen here in the background stood Whiteley Wood Hall, once Thomas Boulsover's home (see pages 20 and 21).

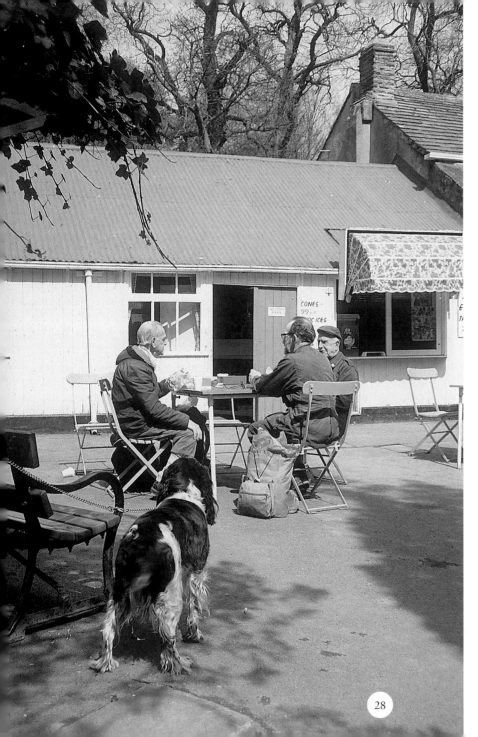

At Forge Dam

The topmost dam on the River Porter was built to power a tilt hammer. Actually there were originally two dams here, the existing one and another immediately downstream, between the Porter and the drive to the forge buildings. It was filled in many years ago. The earliest known mention of this forge is in 1779. At that date Thomas Boulsover was the owner and the forge was producing saws. Through the following decades the place expanded to the extent of having a steam engine and a pair of water wheels but competition from more modern technology closed it down by 1888 when John Denton was operating it.

Happily the remaining dam was subsequently used for rowing boats and this continued into the 1960s. The site of the forge has long been a popular café and is open every day of the year. Here you will see an assortment of humanity - happy families feeding the ducks or playing on the swings, strollers with all manner of canine friends, solitary ramblers and large, chattering groups on the way to or from the head of Porter Clough.

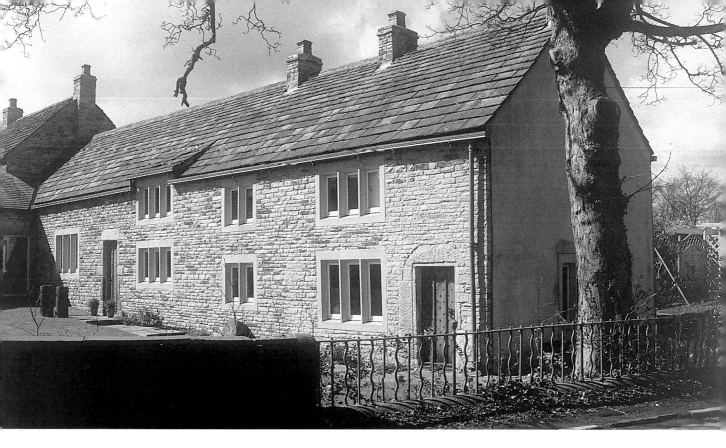

Far Whiteley Farm

The attractive hamlet of Woodcliffe occupies a level terrace called Whiteley Wood Green (sometimes called Far Whiteley Wood) on the southern flank of the Mayfield Valley where Hangram Lane joins Cottage Lane. Much of the characterful old property here was in the ownership of Sheffield Corporation and several stone slated roofs were covered in the tell-tale green waterproofing as first aid for leaks until recent years.

The great Sheffield artist, Stanley Royle, RA (1888 - 1961) lived at one time in neighbouring Priest Hill Farm, using it as a base for painting expeditions here in the Mayfield Valley. One of his finest paintings is entitled "Winter Morning", dated 1925, and shows a pair of Shire horses being led into the field on a snowy morning under a frosty, cloudless sky with Far Whiteley Farm behind. In the composition Royle has moved the large tree seen here a little to the left and created a gate for the horses to pass through, otherwise the details are readily recognisable eighty years later.

Here we see the farmhouse as it is today, completely restored and retaining all the external features that Stanley Royle knew - he would surely approve.

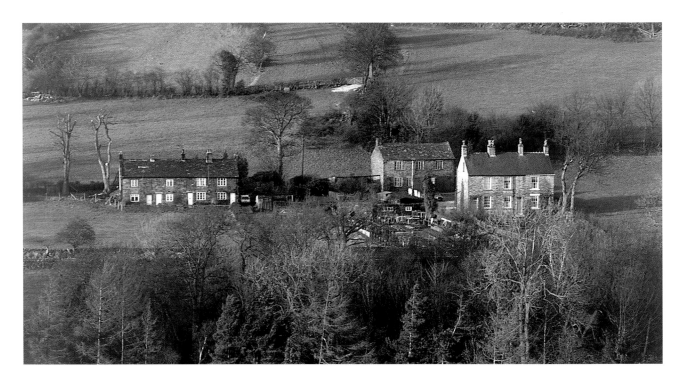

Carr Houses

Here is a view from high on Woodcliffe, looking down to the north into the Mayfield Valley on a bright midwinter's day.

The older row of cottages seen here (left) is Carr Houses. Built of dark, local stone in 1675 they evoke all that is attractive in the earlier domestic architecture of this rural area. It was known as "Water Carr Hall" and subsequently became an inn where, it is reputed, the affluent George Fox of Fulwood Hall wasted his inheritance so that by 1707 his son had to sell up.

To the north-east (seen here behind the Victorian row of cottages) is a pretty stone building which, in the late eighteenth century, was a "Little Mesters" workshop manufacturing files and penknives.

It is known that Robert Trotter lived in one of these Carr Houses about 1800. He had come originally from Scotland and eventually started the Deep Sick coal mine at Ringinglow. Though he kept his tools in a shed near the mine so much coal and equipment was stolen he extended the shed and went to live there. Muriel Hall recalls in her "More of Mayfield Valley and Old Fulwood" that Trotter's Ringinglow hutment developed into "Moorcock Hall", was abandoned in 1862, demolished in 1911 and part of it incorporated into the stone house "Moorcot" that stands at the end of Houndkirk Road, built as a retirement home for Mr Priest, landlord of the Norfolk Arms, Ringinglow (now called "Moor Cottage').

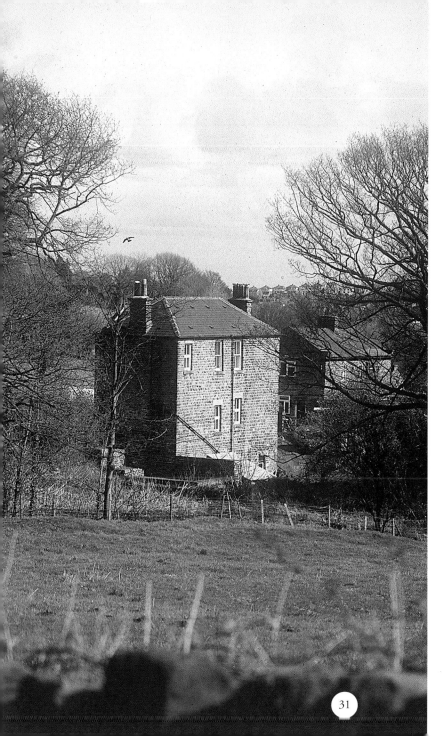

Fulwood Corn Mills

Most of the mills on the River Porter were connected with metal working but Fulwood Upper and Lower Mills were corn mills sited on its major tributary, the Mayfield Brook. It is known that well before 1638 the Fox family of Fulwood Hall owned a "corn mill" in the valley below their home.

Being so near the source of the Mayfield Brook the amount of water available was limited. The Upper Mill had two pairs of grindstones, the Lower Mill had one pair. Both mills were still working in the 1880s but soon became defunct.

The substantial Mill House still exists, seen here from Mark Lane, and silted-up millpond lies immediately upstream of it. The old mill buildings stand behind the Mill House and still serve a useful purpose as part of the Animal Sanctuary (see pages 32) .

They set up their well known sanctuary to rescue all manner of abandoned domestic animals, from cats to horses, poultry to sheep, pigs and goats. In 1982 it became a registered charity, run by the owner and her team of volunteers.

The sanctuary is open to the public most days and contributions to maintain it should be sent to: Mill House Animal Sanctaury, Mayfield Road, Fulwood, Sheffield, S10 4PR (Telephone: 0114 2302907).

Animal Sanctuary

Since the 1960s the Old Mill House associated with the water-powered corn mills on the Mayfield Brook (see page31) has been the home of the kind people who run the Mill House Animal Sanctuary.

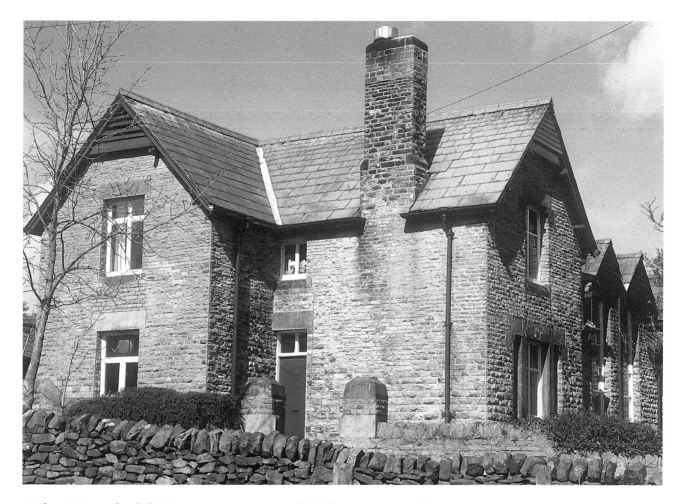

The Mayfield Environmental Education Centre

The former Mayfield School, David Lane was built in 1875 to serve the children of the Mayfield Valley, Fulwood Head and Ringinglow. It stands at the junction of David Lane and Mayfield Road and is today a Sheffield City Council Environmental Education Centre.

The school closed in 1944 and in the fifties and sixties was used as a Special School. At the same time it accommodated the Mayfield Valley Community group, formed in January, 1945, until the late eighties. The Special School closed in 1970 and opened a year later as the present environmental centre. It has a permanent manager and is used by Sheffield school groups throughout term time, set here in an ideal place for such activities.

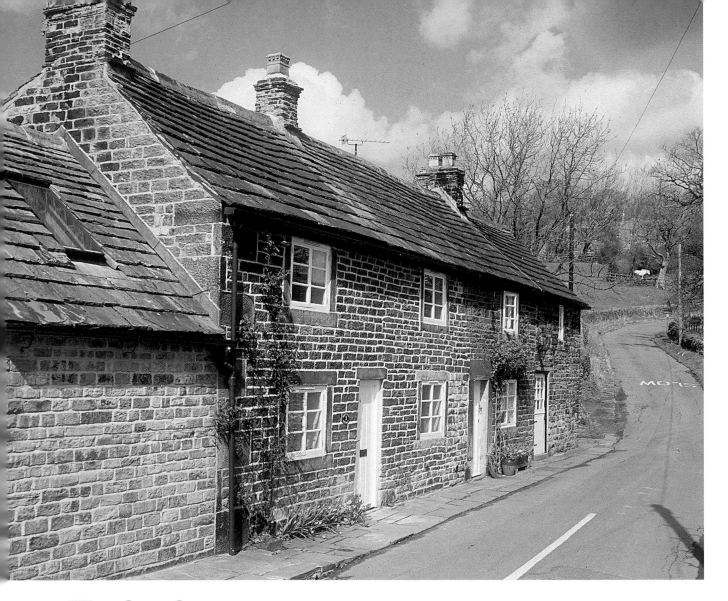

West Carr Cottages

This beautiful row of old cottages dates from 1679. They adjoin the Mayfield Environmental Education Centre beside David Lane and their simple elegance is in contrast to the swashbuckling extravagance imposed on some elderly local buildings by "improvers" possessing more cash than taste.

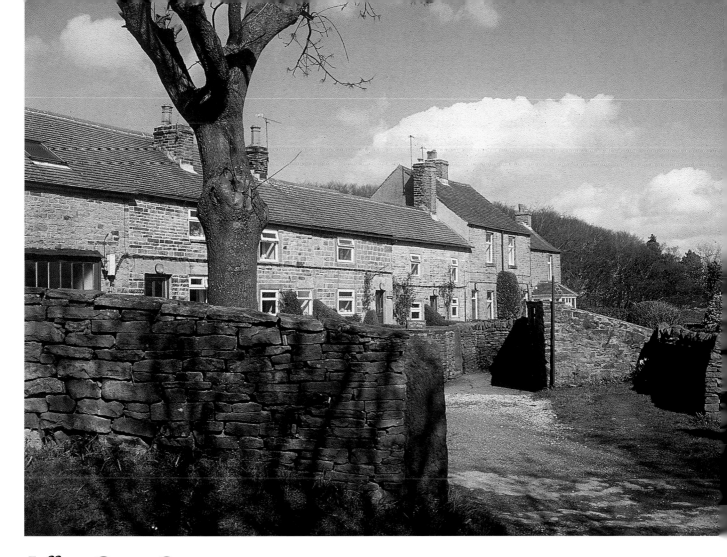

Jeffrey Green Cottages

This attractive hamlet overlooks the junction of Gorse Lane and Brown Hills Lane and lies at 950 feet above sea level. The jumbled row of stone dwellings presents a busy countenance to the world, all the more delightful for that. They face south to give broad prospects across the Mayfield Valley towards Ringinglow and Whiteley Wood Green and beyond; and turn their back on the north wind.

Though there are no fowls scratching here these days, or small hay stacks or carts with shafts pointing skywards, Jeffrey Green Cottages retain a flavour of former times when the district possessed more rural innocence than now.

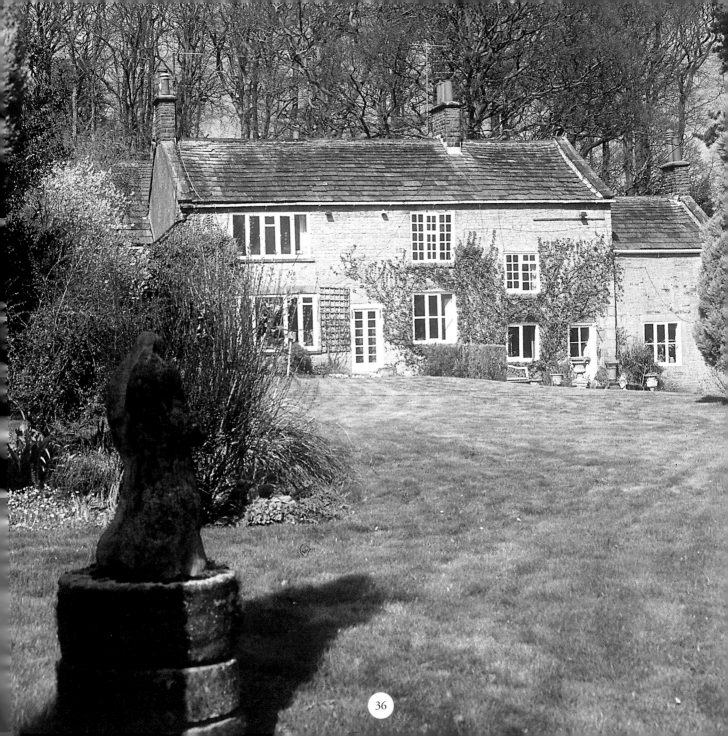

Bennett Grange

Immediately east of Jeffrey Green the lane drops into the shade cast by Bennett Plantation, curving round behind the stone walls of Bennett Grange. A glimpse of the mullioned rear windows suggests the sort of enigmatic romance we associate with Bronte novels; the setting of this former farm helps such association, too.

Bennett Grange was built about 1580 but has had several additions, the last part put up in 1938. It is thought that the farm once served as a staging post for changing horses hauling wagons towards the Peak District, after the steep climb from Sheffield.

The lovely, south-facing garden, completely hidden from the road, is a foreground for a similar prospect to that enjoyed by Jeffrey Green Cottages (see page 35). The mature deciduous trees of Bennett Plantation shelter this favoured corner from northerly winds and hide Sheffield University's Department of Physics Observatory containing a 60cm optical telescope on the summit of Bole Hill (1,024 feet).

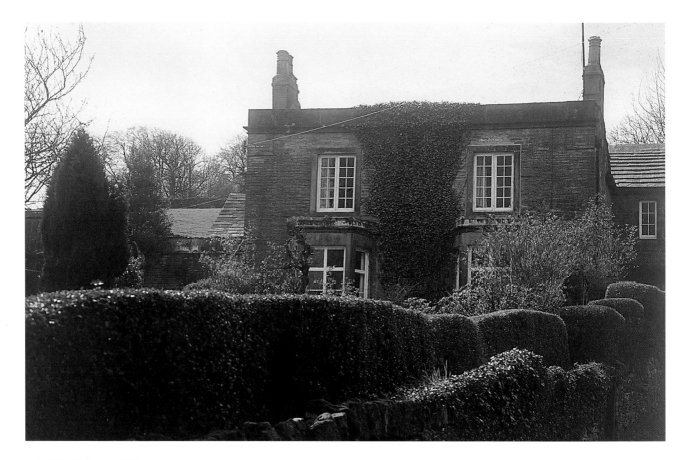

Old May House

This attractive farmhouse stands on the gentle spur separating Porter Clough and its major tributary, the Mayfield Brook, to the north. A map of 1905/6 shows the public footpath that still crosses the fields from Workhouse Green to Porter Clough and so up to Ringinglow. It passes immediately to the rear of Old May House.

Here we really are out in the open countryside of tilting pastures punctuated with little woods. Old May House was originally built in 1750 and a century later the Price family, owners of the Upper Corn Mill (see page 31) and who later moved to the City Flour Mills, Millsands Bridge, Sheffield, were living here and must have been prosperous enough to improve the house with enlargements to the east front (seen here) and a pretty stone porch facing Foxhall Lane.

The property is now in the ownership of Sheffield City Council and is a tenanted working farm.

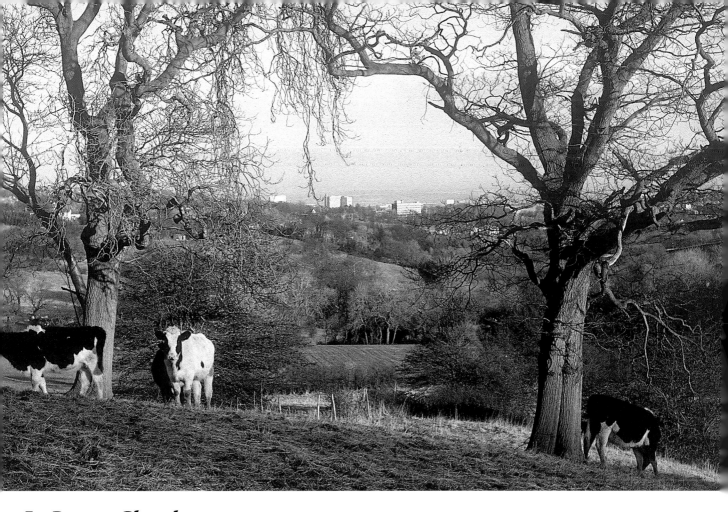

In Porter Clough

As the main valley rises towards the west, towards the high ground of Clough Hollow on the very fringe of the gritstone moors, it narrows and becomes what is generally known as Porter Clough.

Here we see overwintering young cattle near the site of former Clough House, on the path that connects Ringinglow, Porter Clough and Old May House. It is a sunny December afternoon with glimpses down the Mayfield Valley to the tell-tale tops of Sheffield's Royal Hallamshire Hospital (centre) and the former Hallam Tower Hotel (right).

In no other major British industrial city could you find such unspoilt rusticity so close to its urban heart. Here is a jewel that must be protected at all costs.

Champion of Old Fulwood and The Mayfield Valley

If anyone could claim to be the Champion of Fulwood and the Mayfield Valley it must surely be the late Muriel Hall of fond memory. Born in 1912 at Malin Bridge, Sheffield she was the daughter of Beatrice and Henry Wood. The family later moved to Stumperlowe, Fulwood but Muriel was educated at Queenswood School, Eastbourne and it was here that she learnt to ride and became a keen tennis player. She later took up squash and was a keen golfer with a handicap of seven.

In 1937 she married John Theodore Hall (known to everyone as Theo) and they lived at Brook Lodge, Brook Hill, Fulwood where Muriel bred and sold budgerigars and, through the second World War she kept geese and bees. By 1947 her two daughters, Suzanne and Rosanne, were aged five years and eighteen months respectively when Muriel was struck down with polio. Though she never walked again Muriel was made of stern material and to the end of her life was involved in a broad spectrum of activities and responsibilities.

During the fifties she was Secretary of Sheffield Polio Fellowship and thereby took up archery and swam regularly. At this time, too, she discovered the Mayfield Valley Community Centre (see page 33) and plucked up enough courage to see what it was all about. She later remembered finding "well known faces beaming at me from the moment I arrived" on that first foray. A firm friendship was established with John and Ruth Ardron of Fulwood Heights, Harrison Lane, and with Hilda Potts who lived with them. John was President of the Community Centre and Muriel soon became a committee member.

In 1962 Muriel realised that some sort of society was required "to keep a close watch over the wellbeing of our much loved places, especially the Mayfield Valley". What made her determination all the keener was the desire of the then owner of the land behind Fulwood Hall to build 250 houses there. A Public Enquiry had fortunately thrown out this monstrous proposal but Muriel was aware that similar plans might be put forward in the future and best be opposed if a strong conservation society existed. With the support of her friends and Gerald and Ethel Haythornthwaite of the CPRE Muriel organised an inaugural meeting that was held in Hallam Methodist Church Hall. She became the first Chairman of the Fulwood Society.

After separation from Theo in 1965 she built a delightful stone bungalow on land adjacent to Whiteley Lane that gave views across Mayfield Valley to Priest Hill Farm and this allowed her to develop her considerable knowledge and love of gardening despite her physical handicaps.

But perhaps Muriel's most important legacy, alongside the creation of the Fulwood Society, was the recording of the district's oral history at a time when many older residents could tell her of its rural past. Had she not gathered this information in the fifties and sixties many details of earlier times would have been lost forever. This garnering resulted in two books -"The Mayfield Valley" (1972) and "More about Mayfield Valley and Old Fulwood" (1974). Muriel died in December, 1991.

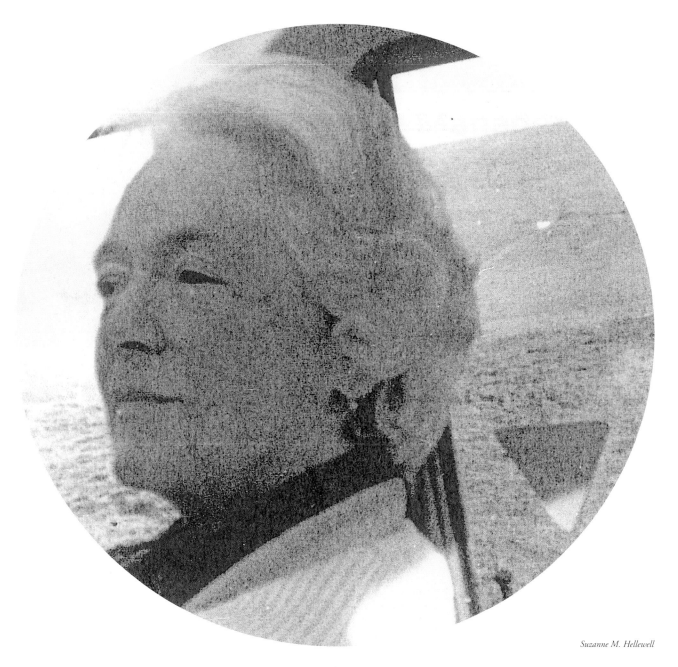

Suzanne M. Hellewell

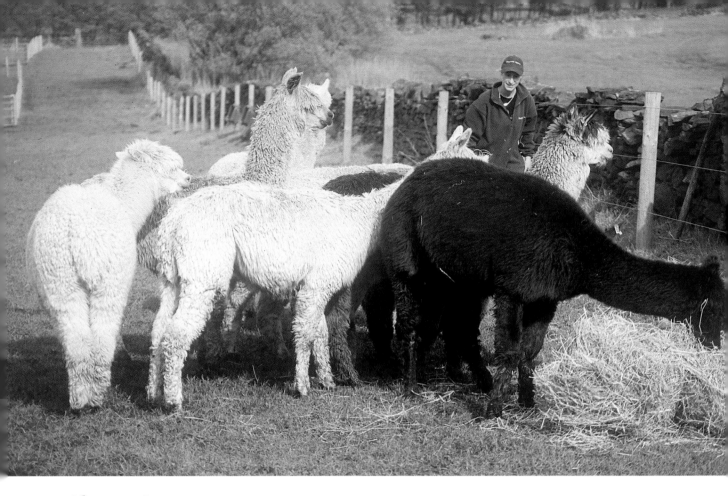

Alpaca Country

If you look carefully you might find black tyre marks on the surface of Fulwood Lane a short distance north - west of Ringinglow. Most of them have been caused by motorists looking through the trees towards the east and suddenly seeing strange creatures grazing the fields beyond - alpacas!

What on earth are these relations of the llama and camel doing up here, a thousand feet above sea level on a south Pennine hillside? Elaine Sharp (seen here) and her husband live at nearby Bassett House and bought their first pair of pregnant female alpacas in 1991 but they only had 1.5 acres of land available there; if their hope of developing a large herd was to materialise they needed more land. Fortuitously a block of 42 acres beside Fulwood Lane came on the market the very next year and they were able to purchase it. Permission was sought and granted for a purpose-built agricultural building. Situated adjacent to Quicksaw Plantation the name for the new farm was obvious - Quicksaw Farm was born.

Though young alpacas are sometimes used as meat in their native South America they are usually farmed as producers of the finest wool. Adult animals produce a fleece weight of three to five kilograms each year, its quality depending on the fineness of the individual fibres. Cold weather presents no problem to animals used to temperatures as low as -15 degrees C in the Andes but because alpaca wool, unlike that of sheep, doesn't contain any lanolin wet weather can affect health so field shelters are usually provided. The Sharps keep their animals under cover during the winter but they stay outside 24 hours a day between April and October.

Experienced shearers from New Zealand come to this country each summer to shear all our herds. The Quicksaw fleeces go to a local spinning and weaving group to make high quality hats, gloves, scarves, etc. which are then marketed. Elaine Sharp is a very busy person. Alongside the daily routine associated with animal husbandry she is in great demand for after-dinner presentations and welcomes groups of visitors to Quicksaw Farm. There are plans to open a Visitor Centre here during 2005.

The sight of multi-coloured camelids on the slopes above the Mayfield Valley is an added attraction to an already lovely environment.

Elaine Sharp can be contacted at Quicksaw Farm, telephone 0114 230 3549

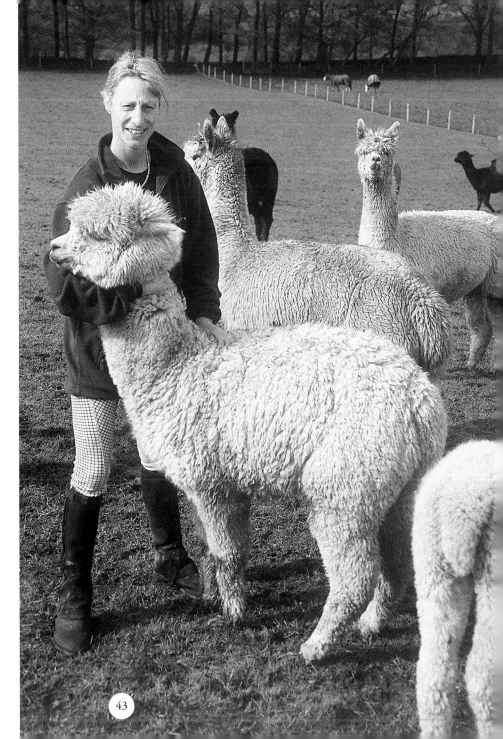

George Edward Flint

exactly two centuries later it was the home of William Andrews.

In 1911 Joseph Edward Flint and his wife moved here (seen here in front of their house soon afterwards) to try their luck on a holding that had been neglected. It is a rather bleak spot anyway, with steep land and a reputation for infertility. Muriel Hall recounts that Albert Flint, son of Joseph, told her that Fulwood folk gave his father two years at Bower Hill - "one to spend working there and the second to serve a year's notice". But they weren't reckoning with his good living and hard working nature and Joseph got the farm into good shape before moving about 1929 to neighbouring Green House Farm beside Andwell Lane. Albert took over from his father at Bower Hill while his father continued to prosper at Green House Farm where he produced 80 gallons of milk each day for Lodge Moor Hospital, making a goodly income. Joseph later retired to nearby Upper Bassett and finally moved to live with his other son, Wilfred, at Brown Hills Farm, Brown Hills Lane in 1947 and died in 1955 aged 91.

Bower Hill Farm

Through the twentieth century the Mayfield Valley suffered the total loss of several lovely old properties that should never have been destroyed. Most of these losses were at the hands of Sheffield City Council, a body that should have been setting an example of conservation not casual destruction.

One such loss was Clough House, close beside Clough Lane; another was Bower Hill Farm beside the junction of Clough Lane and Greenhouse Lane at almost 1,000 feet above sea level. The site is marked today by a nettle-ridden enclosure beside a stand of mature deciduous trees. John Bower was living here in 1592 and

In their wisdom Sheffield City Council demolished Bower Hill about 1968 on the grounds that it wasn't fit for human habitation though the expenditure of a modest sum would have saved it. Today such a farm would be a most desirable residence with its commanding view down the length of the Mayfield Valley.

Near Fulwood Head

Where Fulwood Lane climbs towards Fulwood Head there is a super view in clear weather, eastwards towards the Mayfield Valley's green recesses with Fulwood beyond. Here, sheltered by sycamore trees, is Green House Farm.

Muriel Hall related that Charles Hutchinson and his wife came to live at Green House Farm in 1853. Mrs Hutchinson wanted to go to religious services regularly and got her father, a Sheffield butcher, to build a chapel in the corner of the field opposite the farm, at the junction of Andwell Lane and Bassett Lane. This tiny chapel was only used for twenty years up to 1873, known locally as "God is Love", quoting from the carving on the door lintel. By World War Two it was ruinous and the site was eventually cleared. "God is Love" is no more.

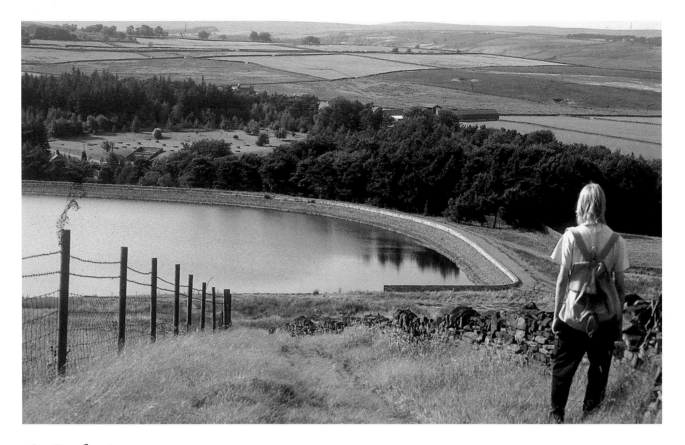

At Redmires

Here on a fine August afternoon we are looking towards the north-west from the path leading over the gritstone quarries at Fulwood Booth Farm, about 1,180 feet above sea level. Below us is Redmires Lower Reservoir and beyond it Redmires Plantation, Ash Cabin Flat and, far away, the crest of Derwent Edge.

The three Redmires Reservoirs are the oldest still supplying water to the city of Sheffield. The Sheffield Water Company was formed by Act of Parliament in 1830. The Redmires Middle Reservoir was the first to be constructed and the Upper and Lower ones were added after another Act of Parliament of 1845.

These three reservoirs flooded the original route of the Roman road (the Long Causeway) that linked the camp at Templeborough, Rotherham with the one at Brough in the Hope Valley. The part-paved way can still be followed beyond the end of Redmires Road, south-west to Stanage Pole and slantwise down Stanage Edge.

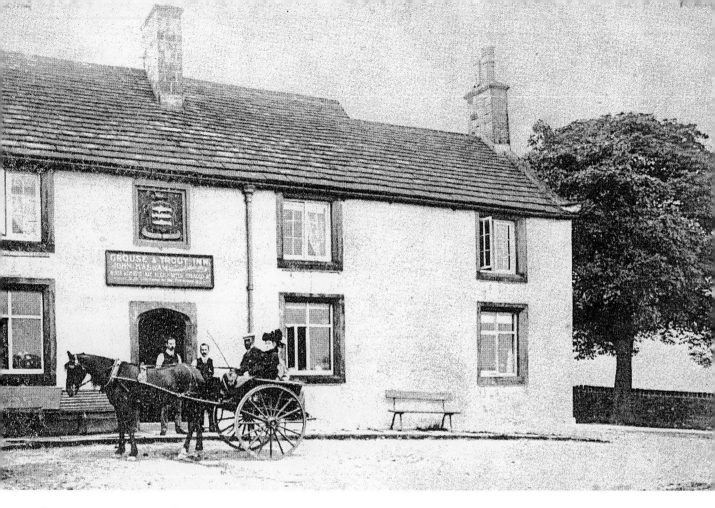

The Grouse and Trout

This old photograph shows the Grouse and Trout Inn about 1900. It stood at 1,150 feet above sea level beside Redmires Road and overlooking Redmires Middle Reservoir. Its site is easily identified because the carved stone inn sign that is seen here over the front door is now set beside the gateway that led to the inn.

In 1913 the owner, William Wilson of Beauchief Hall, had the licence taken away because he thought people arriving by the new bus running from Manchester Road to Lodge Moor would "infiltrate" his adjacent Hallam Moors and spoil his sporting interests. Twenty years later Sheffield Corporation paid £6,250 for the Grouse and Trout Inn, nearby Ocean View public house and Lord's Seat Farm. Ramblers were able to get refreshments at the Grouse and Trout Inn until 1935, when the Water Committee condemned the house and soon after World War Two demolished it, fearing "contamination of the water supply".

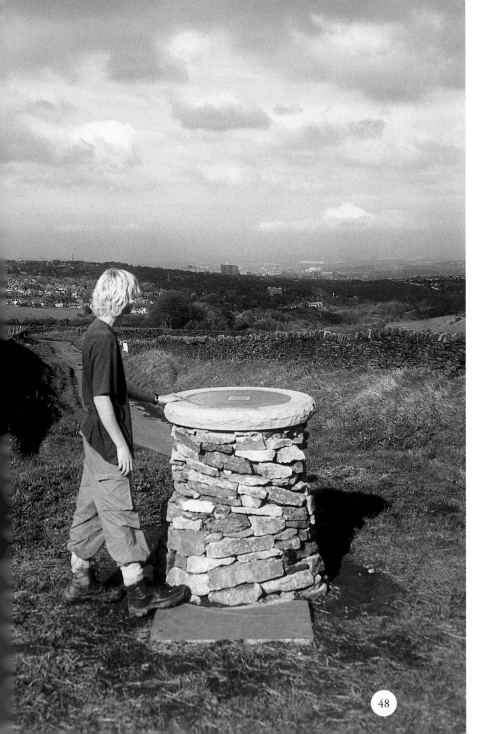

The Viewing Table

We end our journey at 1,055 feet at the junction of Greenhouse Lane with Fulwood Lane, right on the eastern boundary of the Peak District National Park close to Clough Hollow where the Porter Brook is born.

This viewing table was erected here in February, 2005 by local Rotary Clubs to celebrate a century of Rotary International Services. The table details some of the landmarks visible in clear weather. Few British city viewpoints can claim such variety and such distances !

They include central Sheffield (4.6 miles), Emley Moor Television Tower (18 miles), Ferrybridge Power Station (28 miles), Drax Power Station (35 miles), Scunthorpe Steel Works (42 miles), and Lincoln Cathedral (43 miles).